Lauria/Frasca Poetry Prize 2

And Not to Break

ALSO BY JANET SYLVESTER

The Mark of Flesh

That Mulberry Wine

And Not to Break

Janet Sylvester

BORDIGHERA PRESS

© 2020 by Janet Sylvester

Cover photo by M. Rapine, c. 1883, after B. Desgoffe. Optics: a soap bubble exhibiting interference colours. Coloured mezzotint [?]. Credit: Wellcome Collection.

Library of Congress Control Number: 2020931075

All rights reserved. Parts of this book may be reprinted only by written permission from the author, and may not be reproduced for publication in book, magazine, or electronic media of any kind, except for purposes of literary review by critics.

Printed in the United States of America.

Published by
BORDIGHERA PRESS
John D. Calandra Italian American Institute
25 West 43rd Street, 17th Floor
New York, NY 10036

Lauria/Frasca Poetry Prize 2
ISBN 978-1-59954-162-4

CONTENTS

PREFACE

I

Marionette Lines	13
Shanks' Ponies	15
Marais des Cygnes	17
Ragged Man	18
Barometric	20
Blue Dress Video	22
Breakwater	24
To a Feminist Psychologist	26

II

Thrown Porcelain	31
Courtesy	33
False Cape Landing, The Horses	35
Unbinding	36
Field Glasses	50
The Rainbow	51
Poetry	52
Hard Frost	53

III

Baby	57
Away from the Flock	62
Horizon	64
After-Hours at the Museum of Tolerance	66
Tu Shu and the Pear Tree	68
Sea Smoke	69
Prologue	71

NOTES

ACKNOWLEDGMENTS

ABOUT THE AUTHOR

PREFACE
by Spencer Reece

This book is a sustained triumph: unique and refulgent and lasting. Twenty-three years have passed since we readers held a new book of poems by Janet Sylvester in our hands. But now, at last, her poems—measured, whimsical, complex, cured by sorrow and challenge: they show the clarity that comes from living and honing words over time. The speaker admits, "Whatever I used to know doesn´t matter." The poet has lost a mother who was difficult and an ex-husband who became homeless. Yet her poems shine with courage and resilience, containing what I am most looking for these days: hope. Hope is not an easy virtue to catch in paint or with words, yet here it is, captivating and multilayered as in a Durer or a Da Vinci. "To be human is first to try to flee," she writes with a dab of undiminished gold. Sylvester has lived and loved on this planet for double the amount of time as Sylvia Plath, for instance, and thus has earned lines such as "I like winter, I like to have lived through its worst." With her years of waiting and enduring and celebrating and persevering has come a circumspect but resolute hope in life that is glued into these poems' very spine.

I

MARIONETTE LINES

The English shrink who reports that January 24th
is the most depressing day of any year,
isn't in this poem on January 25th—clouds
replete with snow, the moon milkily absent,
roadside drifts beginning to steam at every corner
already awash with slush. I like winter.
I like to have lived through its worst: the solvable
problem of the child buried by the plow,
the convict's commutation dropped into wet
that merely soaks its envelope—and crows,
dozens of them, bunched like onyx apples
on the trees' bare branches above my car.

Tonight it's better not to look too far. Instead,
I focus on the oval the little Christmas tree,
untrimmed and living still in its green container,
breathes clear into the window's icy vapor,
down which runnels drip that, tomorrow,
will freeze into pretty snowflake-shapes with sun
the weatherman assures us is on the way,
along with a drop in temperature. Whatever
I used to know doesn't matter. My student,
who wasn't awarded the scholarship,
in a hand-written note has informed me, nonetheless,

with all of the politesse of Mumbai and many
of its syllables, that he thanks me; the insurance man-
of-few-words assures me that my check's been cashed;
a choking and unsayable distress, like loneliness,
that overcame me this morning in a waiting room
that had flooded and was crammed with industrial fans—
all are one thought about what it will feel like,

someday, to be old: a primary-care physician,
as mine did, examining, then lightly stroking
the little finger of the left, my writing hand,
in its ligament an indecipherable ache.

SHANKS' PONIES

After the twist in his guts that nearly killed him,
my grandfather walked to work each day,
his constitutional, on Market Street to the *Vindicator*.
How often did what remains of his father's face
hallucinate him, as in jaunty fedora and shined shoes,
he raised his determination onto the
bridge across the mill-polluted Mahoning?

Because my car's blocked into the garage,
I'm walking two January miles to the doctor's.
Aristotle I'm not, but for thought's thrawn 't'—
for all that, in spite of, nevertheless, however—
complicating 'though,' its rationality cross-
grained. The sidewalks are meringues of ice.
Snow rosettes adhere to branches then, bursting,
drift to air. Clouds, amethyst and gray, stir.

Warmed by a necessity not to need
anything, past blue recycling bins and sacks propped
on curbs rinsed by dishwater sun, I'm
the four-year-old in another winter, slipping
in bad mood and half-buttoned sweater out
of the napping house, one means of being in time,
I suppose, as my great-grandfather, astride
the quarter horse he's breaking for his son,
and thinking god-knows-what in 1909,

doesn't comprehend that, at the crossing,
the engineer will grasp the chain-pull of the train's
whistle, its shrill fingers opening in air one version
of this narrative, word-for-word, as he's thrown,
then dragged down a Kansas road, his occipital

bone a map of cracks, his foot caught in the stirrup
a mile later, where we find him, in his blue eyes
the dust the world is made of.

MARAIS DES CYGNES
(mare-uh duh zeen)

Ralph, the closest neighbor on the road, hoisted a can of beer and scanned his rabbits. He caught, on average, forty pounds of catfish on a trout line every night. On his porch, a car seat spewed innards. One roof-tile disengaged, sliding into a gutter cluttered with leaves. Below the picnic table beside the burr oak, dogs moved; catfish heads dangled from its branches, supper for a trashcan filled with turtles. Grasshopper wells clanked, draining crude invisibly into banks. Threading baling wire into webs, Rex and Pearlie patched the gate vandals had broken again. To the west, weather boiled to a gully-washer.

She hadn't been to Kansas since she was eleven, bareback then, her chubby mount running below branches green-slung with apples. She shook: Ralph's hand, Rex's hand, Pearlie's, greased black to their shirtsleeves, neatly rolled. The men were *mighty pleased* (twang) to meet her. The gate-key fell into her palm above a century of footprints that prairie larkspur, Indian blanket, and yarrow had pushed out of, downstream a doe and fawn fording the Marsh of Swans, sharp-toothed gar idling in its currents. Somewhere, Buchanan's ghost re-signed the deed great-grandmother passed to her grandfather, a horse, spooked by railroad-crossing whistles, having dragged great-grandfather to heaven.

At New Hope, she pushed pennies into dirt against the tombstones of Alexander, and Christiana, born in 1834, and their sons. Laughing, she'd once spilled onto their earth as her pony jumped the creek that fed the Marais des Cygnes. The oilman bought it all: dry grass, waist high, waiting for fire, foxes leaping, inheritance's dream. The gate's long gone, nothing but hardwood, forty years cut down, bobcat and wild turkey, a wind from the southwest, a sky.

RAGGED MAN

Attention's seed-pearl strand
snaps between eye and mind, I'm looking out
when reading, not down and through,
as I did in Virginia, one March day, the letters
of Woolf open on my lap, afternoon
wind high in branches of old oaks, cold
in gusts among leaves palely sheathed—and
there you were—skin vivid, deep brown, your
stride the gliding bounce of a virile man, moving
between two rows of trees that lead up the rise
to the Italianate mansion called the Big House.

One tangle of synapses blurted your distinct
shirt tails, flapping, another your frayed-
below-the-knee dark trousers, and then the mind
said, Why are his feet bare? They were moving
you fast over winter-hammered grass when,
behind one broad trunk, you were gone, vanished
into watery light. Seconds had passed.
In the zero of not knowing, I arrived at the door,
stepped on the porch, walked down the path.
Life had carried you through a seam in air.

Twenty-seven years later, ex-husband, I typed
your name into Google. We hadn't talked
in that long, but I'd seen you, as happens, on
a corner in New York outside a Japanese place,
and you saw me. My last image of you—dun
overcoat, hair a shade too long, your eyes
blinking hard, as I tipped my umbrella down.
I clicked on a page, gone now, devoted to
Maria Callas, in resplendent grief, singing

an aria from Butterfly, I think, out of tinny
speakers and there, clear as notes on a score,
your dates, 1948 – 2007, "always in my heart."

You had been gone already for five years. I
hadn't known, though someone did. Who?
Though I can clearly recall that late August-
Maine-2007 moon, full and silver-tipping
black ocean waves, a coloratura evening,
I felt no signal from you in Miami, then, why
should I, as the fist in your chest broke open.

I found your brother online, offered my need
for details. Yes, periodic rages. A final, lost job.
Time with your sister. Homelessness. Notice
of your death had reached the family only weeks
before me. He wanted to know how I knew.
He was retrieving the certificate that would say,
months later, you'd been found in an apartment,
dead of alcoholism, yes, but not on dirty asphalt.
Like the moment after reading, I hadn't known.
I'd been taught not to recognize what's familiar,
moments of weird surprise. Stay in touch, we say,
when we're afraid someone will travel great
distances through what separates us, and they do.

BAROMETRIC

After the October sky's unbleached-fabric color
above the Federal Building and God's snapshot
of me and the bankruptcy lawyer shaking hands,
after a palm-full of flawed diamonds sold
to a slick-haired salesman, certificates of deposit
canceled and debts discharged, there was still the cat
confined, for the first time, to the house, and he
wanted out. Nose-to-the-crack-in-the-door out.
Still-strong-enough-at-seventeen-to-tear-
the-carpet-from-beneath-the-lintel out.
Gothic-slowly-break-ten-fingers-on-a-blackboard-
meowing-turned-into-a-grating-howl out.
So we would go.

Had I not let him stop to sniff the dead end
of every branch beside the path that climbs
around the knotted veins of the maples, the hill
littered with plastic, amber glass, and a quick worm
levering its length onto a leaf, he wouldn't, in
increments of days, have led me to the meadow,
a dead seminary's yard, over-grown, free
in lowering dark. I had the city, its panoramic
scroll I didn't know I'd find, and the cat,
jog-trotting as if the walk were something
he had to do for urban me—close-reading
a tree's hollow and the blackberry canes'
unaesthetic tangle he'd belly-crawl beneath
and turn around, composed, to look at me.

I started to clean, picking up a can or two
each day, something to do while businessmen
advanced toward polished cars in guarded lots.

Like commerce, I expanded, collecting oxidizing
springs, socks, a tie, in rain that needled dust to lace.
We were nearly happy: the cat gnawing
on grass that he might not throw up, the leaking
braille of poison ivy blind in its advance
across my arch. In birdsong and its counterpoint,
the hourly bus' diesel grind, the two of us were
private, hermeneuts behind a broken building.

Someone, driving west into the Berkshires late
those afternoons, could never have seen or even
dreamed us: on an orange leash, a woman
deep in rubbishy thoughts, walked by a gray tabby
through waste land the Mass Pike passes: how,
as the rain came harder, and she bent to lift him,
the warm world twisted in her arms.

BLUE DRESS VIDEO

Nabokov, in knickers and a flat cap, poses on a rocky summit,
his net, long-handled, balanced in the crook of one arm.
It is 1957. *Small butterflies*, he writes, *all one of a kind,
settled on a damp patch of sand.*

The sky above a traffic jam, thirty years later, slopes
with cloud banks: one still, one traveling like panic, light
intermittent in the west, platinum white.

<p align="center">*</p>

A sloppy sky, one corner slashed, an act of vermilion.
A child buckles on her patent leather shoes,
struggles with the buttons of her blue dress, its sash,
as she walks, undone and dangling from her hand.

It's past midnight. The motion of her cancels—what—
sweet friends asleep, breath against breath and she, again,
again, going carefully down the stairs, across the porch,

onto the lawn. Not even shadows stop her, touching
her hair, the tender place at the nape, her legs.
Some accident has caused this interruption. Up ahead,
police cruisers, blue, flash blue.

The little girl rounds her house to the back, breaks a pane
from the basement door, lets herself in. Her parents gone,
she's careful, a skirtful of broken glass, stepping up stairs.

*

Nabokov, lepidopterist, classified the blues, specifically
the Karner's blue, its wings black-rimmed, fringed
with white. Like those of certain children who survive,
feeding solely on blue lupine.

Revealing, he recorded, *the celestial hue of their upper
surface*. A refuge narrows. The child climbs into bed.
She had not meant that shatter. Parts of her face are wet.

Obedience, really. To have done what one was asked—
suffering registered, touched away, touched anyhow away,
the deep red of her fevers beginning their lives.
Nabokov, as if in dream, black and white on its grainy screen:

Inaudible distortion. A trifle of blue nylon, edged in lace,
in his out-stretched hand. She doesn't know that she won't die
of this. Rhythmic, the heart's wings close,

open, a needle of glass, a whipstitch
instant—*you little tease*. The bridge above the river free,
she's driving home. And then, the micro-motions of a mind that
flutters *like blue snowflakes before settling again*.

BREAKWATER

The Manufactory of copper paint,
 locked above its sum of antique pollutions,
and Ten Pound Island's gulls, were quiet,
 stubbed like push-pins on a windward beach.

All afternoon, we'd studied up on whales
 that church their calves in aureatic troughs
below the surface, or breach the glassy
 ovals of their prints at George's Banks.

No one saw the Carolina Warbler
 plummet into the boat. Imperial-
yellow, olive-green, it hung its three-inch
 vehemence on one and then another

of us, reappearing to clutch the band
 around a pony tail, or balance on a sandal.
Admonished not to touch it, we were instructed
 that northeast gales had forced it

for days above the water. Varnished black,
 the pinprick of its eye examined us,
we thought. *See it see us*, narcissine, we called.
 In fact, it needed us only not to sink

to continue—its fine, twig-colored claws
 gripped to the deck, its feathers scumbled
in its resistance *not to*—as the wind persisted,
 the breakwater's tonnage of granite

abrading glossy light, and at the bow
 a raptus, an opening rose of water

sun inhabited, the vermeil of its corolla
 breaking as a covenant once did,

sudden, brutal in the down-rush, beautiful.

TO A FEMINIST PSYCHOLOGIST

Thucydides of the minutes, I can smell
your distress. Its inaudible hiss
wafts across the forty inches between us
where my heart hangs like panties on a line.
Behind my head and to the right, a clock
ticks on the wall; behind your head
and to the left, a diploma.
You might have been my teenage pregnancy,
if I had had one. Why am I here,
my hands, once still in my lap, now speaking
language I can't control? I watch you
note their opening, closing, one palm filled
with glass, one palm with snow.
What I haven't done presses
a whetstone, some assiduous incubus
I should give up. Thanatopsical?
Clinically erotic? Which are we?
This musk adhering to the air can't be love.
You're scared. One day, though, you'll be my age.
Your forehead's earnest shine will tighten.
Your soul will step behind the stalk
of its successes: busy women,
bleached fresh, back at their desks,
sessions in this laundry room, rocking
on emotion's dryer, long forgotten.
By then, you'll be worrying your child,
inattentive, often, to your wife, strategizing
how to cut back on your practice and get by.
You'll write poetry, no doubt, stuff
that's ornamental and about your life.
Am I cruel enough? Cornflower-blue,
your eyes widen with concern. I forgive

myself for needing you. The rasp of something
new-mown scours the room. Nonetheless,

I want you to accept the fellowship at Minsk
to investigate the social lives of fleas.
I want you never to be treated as I have been
(Harvard male, statistics favor you) and,
because I can't yet confidently hope or
expect to do (trust/trast/v.),
I want to lick your knees.

II

THROWN PORCELAIN

A sooty foam rolled across the sand
then stopped, an unapologetic thought,
like a question.

The table rocked. Visibly thinning
in her own talk's solvent, a painter raised
then lowered her fist.

In obsession's rhythm, the mind
imports itself as answer then, demanding,
rushes into its front rooms

before the door can shut and falls
onto the outline of its body, which cries
spasmodically

all night, and it is always night.
The painter raised her wine glass to a man
who had withdrawn,

un-oxymoronic,
to a European country. Not god,
that French philosopher

in conversation with the loss of happiness,
the painter raised a knife at right angle
to her upturned palm.

At sentence's end, she made a point
with it, a red joy. Here, a drowned girl,
grammatical, walked out

of the book of moonlight to sit down
in pearl-featured surprise before a house
that's dark inside.

Meet me at the line of her horizon,
halfway beyond the midpoint of a kiss.
But you know this.

COURTESY

I know that you crave fame and doubt your talent
on days which are like places without names
in Ohio. Who hasn't

in the history of dust
that literary reputation is?
Ptolomea's privilege: a cowl of tears

freezes in your weeping, blocks your wit,
self-important as a velvet vest.
I know three things

about tears: how
July's infernal climate forces grief
closed inside the black twist of them;

how their acids, thick with inanition,
stun to life nerves jerked numb;
otherwise,

how they prolong
a flatness, an unattractive town
a child can't afford to return to,

coupled doves deep within an image
of her backyard willow, cut down for years
now, house-tall, only this

in answer to their call.
You lied. Or if not that, exactly, the one
to whom your shape is glued with frost

lied, and you let him. Locked in Lying's Tower
together, its crush of charge and counter-charge—
those razor teeth,

that bloody foam—
your soul escaped into this place to wait
for one you could incant your rationale to.

But I arrived,
my life's directional dyslexia
improved, a little, by the inadvertent

tour you sent me on of perfidy
exquisite in its working out. Somehow.
The icy sheen

on your martini's
barely leaked into a match flame's glaze
in whatever bar your body flees to

up above. Lover of irony, welcome
to its absolute resolve, blind drunk down here,
and only me

passing through
the unantarctic zone of your regret
for you, mine, in a dream last night.

FALSE CAPE LANDING, THE HORSES

I have never seen them sidle
across the meadow's grassy space
to stop in shade or teeming rain
under the wax myrtle tree.

The signs, though, that they cede to me
when I pass by, remain—a few
tough hairs unsubtly scratched against
the tree's gray trunk, above a wheel

of earth churned into mud, congealed as if
blind horses turned in it
some heavy work. I circumscribe
the zone they've marked, one latitude,

where light is bread, and time is good
as flesh that, hungering,
takes all this in. Above the bay,
its edging reeds the depth of tone

a sunset scatters when it's done,
locusts stroke blue air into
flames that flash against the side
a leaping fish twists into light.

The self without itself's not quite
scribbled across the water's skin.
As usual, the mystery
chooses somewhere broken to begin.

UNBINDING

1 Mitochondrial

Seventeenth century: Her hair lava-black, glossy, a woman settles against a low rock. She folds her wet skirt across her feet. The timbre of her eyes reflects little light. For now, her soul is in her hand, an image attracting distances. Pollen eddies in air, lilies sing beside a stone fence mapped with moss. Spring spindles an axis her skin assembles around.

2 Sestinetto

The rain had gone on all day, past the shadow in the window she looked into, the light behind her near and substanceless. Pennsylvania's mild rain, like watered vodka, vaporless. The last bag of lipids, empty, would be unhooked, but not yet; not yet the morphine drip's red digitals and oxygen's—*tick uh, tick uh*. She would begin to choke. A fledgling nurse would fling her stethoscope and run.

3 Dotted Swiss

I love your blouse. The mother said this sentence, which massively outweighs all the atoms. She hadn't seen her daughter in seven years. I must befriend, the daughter thought, the eleven dimensions. She carefully crossed waxed tiles to the bed. I must understand the graviton. In a hospital somewhere in Ohio. Under a cotton blanket, an ingénue distended, feet to sternum.

4 1947

A last-minute date for dinner and dancing at the best hotel in town. He'll pick her up—a model posing as a secretary—in the office lobby at 6:00. At the ten-cent store around the corner, she chooses a black-hat shape (79 cents), a yard-and-a-half of frilly white eyelet (44 cents), and two clusters of poppies (29 cents apiece). The Ladies' Home Companion titled the layout "Twenty-Minute Hat."

5 Over the Rainbow

In the basement, it could only have been the mother who had suspended the needle of the phonograph above this cut on the Garland record. The mother who stepped upstairs, listening for their familiar creak. 200 billion detectable galaxies compose four percent of the cosmos. Her symptoms making hypothesis more than just a wish, she was headed for someplace in the other ninety-six.

6 Hat, continued

5:33—Back at her desk with the little bonnet shape, the eyelet and the two dashing flowers, and exactly twenty minutes left to put them all together, she's thankful that she's learned to keep a little sewing kit in a drawer. She sews one row of eyelet edging inside the hat brim and two rows on its outside. The prototype of the poppies grows in an ancient generation of stars.

7 Choking

Swallowing the hot-pink liquid a nurse tipped at her lips, the mother flushed that blue-color of early-evening snow she'd once polaroided: A row of small, white houses, a street unplowed, a spruce tree in the yard of the neighbor she claimed was a serial killer because, as she knew, he came and went at strange hours. She had monitored him above the static of the police scanner beside her bed.

8 Baby

A mother bends above her daughter's naked body. We cannot see the mother's face, but something like a smile's in the shadow of her cheek. She holds the scrawny infant above water in a white enamel basin, used afterwards to mix torn bread and onions for stuffing. The child appears startled, eyes wide with traveling through the depths of a woman in a yellow sundress.

9 Scrapbook

Philodendrons in copper on blond furniture, red sectionals, venetian blinds. A little girl sits cross-legged on the carpet, a big binder open across her knees. Each of its photos and clips is neatly mounted, plastic-bound. Her mother's shapes: in ankle-length plaid skirts, in pedal pushers, in a taffeta gown. The child examines the face above a bathing suit, black, a white panel ruched at its midriff.

10 Scrapbook, continued

The mother puts a finger to her lips, rouged deep maroon, above a sweater, three-quarter-sleeved, completed by pearls. Across the room, with almost masculine attachment, she watches her pudgy child breathe in. The camera's lack of homeliness contradicts demand: Skin closed to touch, lips opening a little. The child wants to cry. Later, she'll buy her own swing jacket, cashmere gloves.

11 Hat, finale

She tries the effect of the red petals against the hat—pins them at several different angles before a mirror in the cloakroom. Clean white gloves kept in her desk for emergencies add the finishing touch. On time, her date meets her in the hall. The child can't notice—as the photographer might have—that the woman wears an engagement ring in every frame.

12 Model Child

After many years, she finds an early photo of the mother: complexion drab, hair lank, dark eyes' gaze afflicted. With the postural resignation of a school picture—or of one in whom shame has been brutally aroused—the ten-year-old clasps her hands, nails bitten, on a grainy desktop. In those fingers, the future's ambience of the lady-like is stripped away.

13 Quantum

Each historical event of matter emits one, usable by the future. Formed as an orange Volkswagen bug smashed on its passenger side by a van, this hologram reenacts attempted murder, evidence circumstantial. When she drank, the mother hated her daughter, who had time only to cry, *Oh mother*, and to note the black ice that had become her mother's eyes. Then the car began to fly apart.

14 Rope

Take one and use it to tie your leg to the hospital bed, the daughter's friend said. The mother swelled and, swelling, stank. In the catheter bag, shreds of her bladder floated, suspended in yellow liquid. *I am*, she whispered, *afraid to go to hell*. A priest came. Crossed with the oil of unction, her forehead glistened. *This is hell*, the daughter said. Each of their wrecked senses had been blessed.

15 Bridal

A brittle newspaper clip. The bride wore an imported white organza gown, and carried a Colonial bouquet, centered with white orchids. After the football season, the couple would spend two weeks in Bermuda. At the end of the clip, lines of filler someone had carefully not scissored away: 'Most tornadoes in the United States occur between noon and 6:00 p.m.'

16 Small Rocker

Under its seat a music box, red, affixed to that, a string and wooden ball. During their nap, the child had tied the mother's auburn page boy into knots, meaning that head was filled with problems. With precision about what isn't desirable, and what is, she then painted the master bedroom's dresser with red polish. *Cheer her up*, the polish said. For these bright deeds, she rocked and rocked.

17 Milk Glass

The mother drank in the kitchen, late at night, a beer bottle on a napkin folded neatly, close to her hand on the milk-glass table. Shell olive, gold and copper, in over-lays washed with sepia-gray, a demon crawled across the suburban street. A shawl of flies shifted across it. On the mottled linoleum, a snake began to dilate, the etiquette of the venomous, excruciatingly correct.

18 Thai Silk

A dress worn once: leaf-tremble green, its sheath an antiphon to the closet, high heels in position beneath it. For years the mother slept until three, then rose, on occasion, at her daughter's coming home. Afternoon's amnesiac return—as if her only world encircled a schoolgirl. In the suburb's winter light, the mother's face valiumed to smooth youth as she unpeeled foil from frozen dinners.

19 Glass Harmonica

The source of light behind it blank, fluorescent, disincarnate. Hours before, player piano manic, she'd applied, then re-applied eyeliner. She whispered into the ear of the mirror. Calibrated into octaves, tumblers of scotch spun into the difference in pitch madness makes, male, female. A family. Now the snake's spermatic head raised above them all.

20 Stutter

The mother wrote, in 1976, under the full-page swimsuit ad: My last pro job, $325.00. She was forty-eight years old. 'Does summer make you go two pieces?' the copy asks. Catalina suits 'pull you together like no other swimwear does!' The model in the Jackie-O glasses is, maybe, twenty. ' Too many to choose only one', the copy goes on, 'cover-ups come in small, medium, and large.'

21 Stutter, continued

After the suicide attempt of 1975 (there were others), the mother wrote on the ad and tucked it into the scrapbook's back pocket, along with her first modeling agency contract, both discovered by one of the daughter's friends, in 2005. 'Those aren't my mother's legs,' the daughter commented. 'On the other hand', the mother's oncologist once quipped to the daughter, 'I didn't know you existed'.

22 Wig

Ashy flaxen, its underside visibly stitched, it lay on a closet floor. The daughter, who had arranged the accoutrements of the funeral, was instructed to locate it. But she's beautiful, the daughter said, as she is. 'Protocol and relatives'—the funeral director intoned, in his workroom hung with metal instruments, tubes, and shelves of jars filled with jewel-colored liquids—'require hair'.

23 Mini Opera

So, how do you like the way I'm doing my death?, the mother asked, and then winked at the daughter, ready for a Valium shot of her own. Finally, a job had found the mother that only she could do. She was jaunty. She wanted a cigarette. The daughter could not have imagined that she would find her mother only in that tiny subset of all the possible worlds in which to exist. Here.

24 Coma

In the bombed Uffizi: The daughter paused, pockets filled with lira, at Eleonora's mineral calm. A Bronzino *ritratto*, Medici polaroid—she's Easter-lily complected, her necklace pearl, red-gold, heavy hair. The mother's money fluttered upward into the dark, from San Lorenzo. Verdi poured from loudspeakers, the cobblestones of the piazza drenched with Requiem, an evening shower.

25 Her City

Construction netting, funereal and salmon-shaded, rippled in wind. Trinity's gravestones in dirt concrete dust had fused; glass-shards, twisted metal bits frozen to it. Computer tape tangled in trees' burned branches. An in-breath of grit. In 1947, she rose, tied a black ribbon into a bow at the throat of her white blouse. These plumes of steam, she'd never live to see.

26 Probability

It doesn't break, it stretches. The stretched field connects us. At the cemetery (1992), after chains had settled the concrete lid onto the concrete vault, the mother's brother asked, *Is that thing locked*? Cargo of starred dust, a twenty-five-year seal. One soul. Many. Attracted, repelled. Dark matter, outweighing all the atoms.

27 Order of Touch

At the end, her feet were mottled, cyanotic blue. The daughter kissed the mother's lips, her eyelids. Careful *fleurs de peau*. To the loss of pattern that is death, the daughter offered the wrong-colored casket-dress the mother later demanded in blue. The afterlife, some say, is conditioned by expectation, like this wish, her last: Somewhere, my mother puts on little red shoes, to go dancing.

FIELD GLASSES

> **refrain** n. LME. [(O)Fr.*refrain*,
> *refrein*, prob. f. Prov. *refranh*
> bird's song]

Though birdsong shelters in the word *refrain*,
that stallion, several mares and pair of foals
the water meadows utter, stand in rain.

And noisy geese lift wings, black-tipped, to stain
the sky above the reeds. The wind unrolls
as their song shelters in the word *refrain*.

I know that loss has nothing left to gain
today from me. I'm made of parts and holes,
personified as standing water in the rain.

And still the afternoon's gray circle drains
ditchwater into oily flame. The cold's
outside and in, despite the word *refrain*.

Six horses the ocean once contained,
half drowned, half swam across the shoals
then jumped the meadows in the water, climbed the rain

to turn to me their dark regard. Darkly sane,
a dream the world invents of time unfolds
inside a water drop. The word *refrain's*
from Provencal, which spoke in birds and rain.

THE RAINBOW

A bloody trail of Cs wheeled across her calendar's white blocks,
one for each time she cried. Ash of summer fires above the Arboretum
whitened her hair, her ribs jutting under cotton as I climb
hindsight like a fogbow's tricky replica, around our shadows circles
of light called 'the glory.'

Afternoons before her hand fixed cold around a music box's key,
its melancholic kitsch in a plush horse that cantered with her
on its back out of the world, I sat with madness, its child's voice,
childish gestures, rain-sheets scattering behind her eyes.
The Avenues back-scattered with smoke.

What she did, months later, drew hunters to a perfect place,
aspens fret-worked with frost stenciled on the windows of her car,
which she'd taped. At her piano, she'd played the milk and ice
of Schumann, a final mind. I couldn't read
in her exultant face the method of her plan.

That's how, she said, Westerners do it—at midnight in a canyon—
though we had fed the sickness ice cream, any flavor
it wanted. Though it ate scrambled eggs, an only meal for days,
and last, I can say now, sugar cookies. She grew
to thirteen, arms skinny in a pink A-line, purity diluted to a smear.

I opened her apartment door to perfect order: a small lamp
lit, fresh box of tissues beside it. Every surface polished with fury.
Her note a crypto-grammar, no words in it to misconstrue
taped to a no-door in the no-place that opens before me,
still, grief, constant as a waterfall in air.

POETRY

The world was small: one window high up,
admitting early evening light,
a simple table, lustrous with use, two chairs.

You took your place. After a day or two
you took my attention as anything broken
that hasn't been wept over does.

Enumerator, you counted out your flaws,
chief among them, fear of the ecstatic.
You craved to be away from where you were.

Here you are, away from where you were.
We walk below the dark crowns of trees,
their shadows given mass by yellow streetlamps.

HARD FROST

Hank of vines, clematis and morning glory
hangs from the arch before the courtyard.
The long stems of dahlias blacken
against the fence and bend, petals
the bloody rough, now, of gems untreated.
We talked for hours, didn't we,
quick air scouring the ground?
The stars went out. And then,
behind the hollow's gold where the pond's
still blue accumulates like filigree
on leaves in rimy grass, the rattle
and whuff of the heron, blue, harvests
its image, lifting above a skin of ice.

III

BABY

Baby, for a long time, has been reading
A Short History of Modern Philosophy,
It doesn't console her. Marxism's lasting
value doesn't console her. The death
of timelessness into history
can't console her self, self, self,
aware, alienated, realizing. She accumulates,
like surplus value, years recorded
on a driver's license. Too much
wonderful self to go around,
she goes around, a fit of pique
and torque. She hopes for a modish personality
disorder, and *poof*, her wish is granted.
Her shrink, forgiveably, yawns. The sound
of Baby's love's a ticking escalator
in an empty airport somewhere in Bahrain.
Now Baby yawns. The sound of her love's
the infinitesimal wrinkling of a teabag
drying in a saucer in the 12^{th} Arrondissement.
The sound of her love's the whirling death
of a moth in a web strung between branches
of sagebrush in Utah. Baby doesn't want to:
a) Change. b) Not change.

A blue, not cerulean—ultramarine—
deepens her. The sound of her love
is the glide of notes in the throat of a thrush
beside an abandoned barn in New Hampshire.

Listen up, boys: Baby
is not a Mommy; Baby's a baby.
She puts the entire world into her mouth:

she tastes a leaf, the satin glide
of taupe in a nightgown, the moss
and rust of light, thirst, which is closed,
hunger's blood-tinged tongue
and beating heart. *Why* is Baby's word.
She yelled it out the window of the car
when she was eight. Naked in morning sun
in an arroyo, she slid it into a rattlesnake.
She stroked it into the small of the back
of every man she loved, breathed it
on the eyelid of her stillborn daughter, caught it,
catches it still, between her teeth
at academic meetings. She's filled with the surplus
value of this feeling. Hours of unpaid labor
accumulate with textile slowness, lengthening
like Bruges lace, a halo of candle flame
illuminating her as she yawns.

The sound of her love is one dark look.
It could go on and on.
Baby considers object-relationships.
Baby considers the wing and the blade.
Rain-soaked, she's marked, the curve of an ache.

The sound of her love is astral dust.
The sound of her love is molecular water
caught in salt in a meteor billions of years ago.

This, by the way, is not a love poem.
Love's expensive, she says,
Love is just way too expensive.
When she's in it, she's a pig in dirt.
When she's in it, she's a wagonload of devils.
Poor baby.

A mirror teardrops onto Baby's brow,
across her cheekbones, into the indent
above her upper lip, along her hands.

Once upon a time's hidden geometry,
which Baby intuited rather than knew
in the endless deferral system called her mind,
Baby met a stranger. She shook the stranger
up and down; she tapped its sternum
she listened at its head (which rattled slightly);
dog-like, devoted, she dragged it like a doll
by one arm, back and forth,
back and forth. She dragged it
into a village built around a garden.
Svelte with tears, she laid it down.
Weak with power, she opened and closed
its eyes, smoothed its fingers, kissed
its little hands. "Ein Mann
und eine Frau," the tune wafted
out of a summerhouse near Prague.
She crossed the song, a metaphor, a footbridge
giving up its distance. She kept
walking. It was a sing-along. She sang:

Spit and sinew, gauze on water,
the law of beauty rude in a world of kitsch.

The doll, which she had almost forgotten,
took on weight. It sweated at her effort,
pulled her to her knees. She aimed
one well-placed slap
at its painted face. It aimed one
well-placed slap at hers.
Counter-weights, they used each other.

They rose. Oh dear, it was much,
much taller than she, now
a man where they played at statues.
Baby spun and froze, hands on her hips.
The man continued to spin. A spinning
penny, he defined one edge.
Baby, not a dissimulator, hoped:
a) He'd save himself. b)
In the parking lot of the Mall of Emotions,
he'd sink forever into spewy asphalt.

He stopped. The thought he thought she thought
was not the thought she thought she thought.

Why, said Baby. He watched her:
not with the gaze of an infinite number
of eyes (which Baby was growing used to),
not with the gaze of the eyes of many friends
(those she would recognize),
not with the gaze of one in love
(that's presence), but with the gaze of one
who's absent (who lives in imagination).

Baby, used to being top banana
in the shock department, waited.
She was at his mercy; he, at hers.
In me thirsts, he said.
Starved out, Baby bathed
in the fog of the phrase. *Talk English*,
she complained. At this, he smiled
like a Czechoslovakian novel. *Why?*
said Baby. At this he smiled like a Roman
pastry powdered with gold. Baby
was no longer yawning. At this

he smiled like an Aztec priest jacklit
by luxury.

 And so, dear listener,
our tale concludes at its decisive moment
on a dirt lane in a foreign country
under trees studded with leaves large
and star-shaped beside a fountain
weeping gardenias into the fizzy
early evening air. Baby
is a fresh horse on a lead line.
Baby's a wagonload of language.
Baby is your surplus in a world
of labor hard and unremarkable.
Baby is what's left over,
when you go home. The sound
of her love is your sleep.

AWAY FROM THE FLOCK

As children tripped against the first hard surf
at Banda Acheh, in New Hampshire,
on a lake where bluish ghost-glow rose
with snow the wind twisted into funnels
above water thickening under them,
ice planes boomed, adjusting at their seams.

Half a world away, a continental plate
shifted into long waves the grey gauze
of TV pixels would make look small,
rolling across beach chairs into palm trees,
little people clinging almost soundlessly
to wrinkles in the muddy current.

At the Museum of Fine Arts in Boston
days later, an acrid burn gathering
at the back of my throat, I sat before
Damien Hirst's sheep, dead of natural causes.
Afloat in a glass tank of formaldehyde,
palely green, it balanced on hoof-tips as
dread does, tendons exposed in the wool
behind each foreleg, and, in its dark face,
eyes rolled upward under tissue-y lids.

Banda Acheh. At a window sleeted
closed, beside a table in which a woman's
back thinned to virtual object, above
a pond white pines and light snow
couldn't interrupt, a fox's reddish
blur skittered, my moral twin, toward
pleating water cold hadn't claimed.

Moving men, in Boston, wrestled
to uncrate the sinews of an art infarcted
as a dying heart. Downstairs, the announcers'
sentences, excited, lengthened exponentially on CNN,
as if what's arrhythmic weren't
life. I couldn't turn it off.

HORIZON

From the box office, back, movie-goers
curve through hot night. In pools,
lit humidity turns to gauze the optic-
white shirts on men's hard tans.
The red dazzle of a lithe girl's dress
softens to rose above her sandals.
Rusty palms creak, tubbed in concrete.

Whether the naked, dollied-in-on corpse
of an Argentine school teacher, half on
bed/half on floor, or Swedish actors,
large-pored in a subway's fluorescent
crime-light, or Mussolini's future
wife in black and white, crushed
like Abyssinia beneath his kiss,

we take to the image. In the Gulf
and five miles down, a vessel's burst,
oil flamed, earth's cerebro accident,
gassy black in its nerves. A dolphin pod's
stained sonar turns vertigo's circle.
Distinguishable beak in bowl of tar, a nested
pelican blinks. Defects in the visual field:

sea creatures float into dribbling
particulates of dispersant. Red snapper
and cobia blanche. The line,
like arm-drift, can't bend to attention,
our bills pushed fast into a slot
cold airs escapes from. In the lobby,
popcorn slicks with butter from a tap.

The state's locked in, conscious,
paralyzed, but for its eyes. Whale sharks
starve in the dark.

AFTER-HOURS AT THE MUSEUM OF TOLERANCE

Where you kin from, Ruby C. Williams asks the miles
of fields, black-shrouded around her ministry
of produce. She grows seed important as painting,
she says, broadcasting winter berries in red acrylic and
industrial green collards onto plywood at her fruit stand.

On NPR, Maziar Bahari, journalist, quotes his jailer,
member of the Revolutionary Guard, who joked,
We can put you in a bag, no matter where you're living.
We control every aspect of your life, no matter
where you are, as he squeezed Maziar's ear
while talking to his own wife nicely on the telephone.

In Cambridge I slide a new book about Anne Frank
from a shelf. In LA, same day, Caerthan and Mary
visit Anne's facsimiles and artifacts before walking
into sun that flattens the surface of what happens
in Florida, or Tehran, or Westerbork, always happening.

Surviving selection, Anne's imagination is assigned
a number between A-25060 and A-25271.
Wrapped in nothing but a blanket and Bergen-Belsen's
ashes, she kneels for the last time beside a straw-bale wall
to whisper to Hanneli. The season's last,
obliterating snow has yet to fall.

Like the torturer's horse that leaves, in this audio tour,
only a hoof print as it plods away, back sagging
under a feather, the interrogator conflates New Jersey—
where Ruby labored for twenty-five long years
before the slave her great-grandmother was bequeathed

her acres I'll not ever get to—with Paradise.
Little changes, but I want us to change a little.
Understand? Bedelu giggles, hiding in a closet,
as Caerthan, frantic, rings his name up and down
the streets' anguished hour. Then, he lets himself
be found, life returning to life in her smile.

TU SHU AND THE PEAR TREE

In peridot and yellow grass, in a xeroxed
 photograph, one cedar at his right, healthily
greening, naked trees beside the river at his left,
 a black dog, part chow part lab, tail raised,
mouth agape in the just-beginning-to-rise sap
 he stands on, turns to our left; everything
plants his forelegs, a little pigeon-toed,
 at the seeming beginning of some path—
behind him, a pear tree steep in its froth.

Byrd Dickerson, they say, planted the tree,
 to look at from his porch across a rope bridge
over the slender Roanoke, slate-colored
 in the night wind now through Ellet Valley,
pressing a train loaded with coal out to Norfolk,
 then to some colder coast. Master
of what he looked at, he couldn't foresee you.

Tu, all those pack-dog years before
 you crawled into the shrubs at Ray and Jerrie's
live now in your grin, moist even in digital
 reproduction, pink-tongued, open to take in
that lofty-scented incense and the musk,
 close by, of a deer's hind leg, leaking
a little marrow at one joint-end, like
 this wish: a poem brushed with your tail
infinite late afternoons, your head
 a heavy temple dog's against my knee.

SEA SMOKE

Frost on a window, indistinguishable from roses
knotted into a curtain, burning
 as blue dawn drains into it
 from the backyard apple, its parabola
of ruddy spheres
what's left of summer. Across the fence, a red boat's dry docked,
buttoned against snow
 that won't arrive until later.
 Warming your hands
at a cup of coffee
in the kitchen, you send your wish into the hemlocks, and
beyond them, to the bridge
 that takes you away, commuting days.
 You want to root here,
into the water's going
and coming, to be home, to be home, in this old place
long skirts hurried
 through to the small barn
 a Mexican restaurant worker rents
now. Instead, you layer sweaters,
walk out to scrape ice from the car, coughing, like luck, into drive.
Past the Square that plows
 have already heaped into drifts,
 you slide onto the bridge
and—how can it be worded—the braiding tensions of the current,
the light the world flows inside,
have turned to precious metals.
 Every register of platinum
 and rose gold issues into
the frigid channel, coaxed
by sun into thermal plumes, bright steam cooling to droplets bent
by air into pyramids—

 dozens of them—
 seemingly still. You
stop, idling for minutes
to let the bridge raise, then drop; the day's first fruit, a form of fog
exhaled by water,
 already gone, as
 the future accumulates
in the rear-view mirror: an apple tree,
dirt-brown, disappearing into the chapel of its vanished leaves.

PROLOGUE

Last night we fell asleep before the end
of the world, another lengthy TV special:
bursting gamma rays, rogue asteroids,
super volcanoes, latent nuclear fiascos.
Awake until computer technologists
created intelligences turned against us,
we didn't wonder why. To be human
is first to try to flee, but then to burn,
drown, freeze and gasp with surfeit
and/or lack. The two bouquets of dahlias,
burnt orange and lavender-tipped, shading
to purple, that you brought back from the market
and mixed, drank hard anyway, their stems
thickly visible in a clear vase, their petals,
candle-flame shaped, perking up.

When we awakened, the end of weeks
of drought and the seventh and final threat
to existence coincided. The worst news
wasn't hard to try to bear. A flooding
fragrance, sweeter than the dahlias,
streamed through the open windows:
dirt cream parsley burnt sugar…
We opened the door to the porch
that hot ghost had pressed against for so long.

NOTES

"Marionette Lines"—Cosmetic-counter lingo for the nasal-labial fold, and the lines from the corners of the mouth to the jaw. This poem is for Laurie.

"Shanks' Ponies"—This colloquial phrase means 'to walk.'

"Courtesy"—A loose reference to Dante's *Inferno*, Circle 8 (falsifiers, betrayers).

"Unbinding"—Sections 4, 6, and 11 are gratefully lifted, sometimes word for word, from the Fashion section of *Woman's Home Companion*, July 1948 (25 cents, readership over four million), in which my mother featured in a photo spread titled, "Twenty-Minute Hat" (111-113). The writer of the captions was not credited.

"Baby"—First conceived, on a dare, as a performance piece for two voices. I practiced delivering the poem with Tom Cole on the empty stage at A.R.T., in Cambridge, MA. We then performed the poem at a reading at the Revolving Museum, Boston, in 1999. "Baby" eventually morphed into its present form, which was awarded a Pushcart Prize, after being published in *Seneca Review*. It's true; it takes a village.

"*Away from the Flock*"—The title of this poem is the title of Damien Hirst's 1994 piece (glass, painted steel, silicone, acrylic, plastic, lamb and formaldehyde solution), one in his Natural History series, exhibited at the Museum of Fine Arts, Boston, in 2005.

"After Hours at the Museum of Tolerance"--The work of Ruby C. Williams, folk artist/painter, minister, and produce seller, informs some of the details of this poem, as does Melissa Muller's book, *Anne Frank: The Biography*, and NPR interviews of Maziar Bahari, upon publication of his book, *Then They Came for Me: A Story of Injustice and Survival in Iran's Most Notorious Prison*. Also in synchrony, my sister-friend, Mary, her daughter, Caerthan, and Caerthan's son, Bedelu.

ACKNOWLEDGMENTS

I would like to thank the editors of the following journals and anthologies in which these poems first appeared, sometimes in slightly different versions:

Blackbird: "Sea Smoke"

Boulevard: 'Unbinding"

Colorado Review: "Ragged Man"

Georgia Review: "Barometric"

Harvard Review: "Marionette Lines"

Memoir (and): "Blue Dress Video"

Prism (Lynchburg College): "Tu Shu and the Pear Tree"

Seneca Review: "Baby"

Sugar House Review: "Away from the Flock," "Breakwater," "Prologue," "After-Hours at the Museum of Tolerance," "Shanks' Ponies," "Horizon," "To A Feminist Psychologist," "The Rainbow," "Marais des Cygnes," "Poetry"

Virginia Quarterly Review: "Field Glasses"

"Barometric" was the featured poem in *Poetry Daily*, May 9, 2006.

"Baby" was chosen for *The Pushcart Prize Anthology XXVIII*, 2004.

"False Cape Landing, The Horses" first appeared in *The Sacred Place*, University of Utah Press, 1996.

"Sea Smoke" was published in *Poet Showcase: An Anthology of New Hampshire Poets* (Hobblebush Press, 2015) and *Piscataqua Poems: An Anthology* (Piscataqua Press, 2013).

"Thrown Porcelain," originally titled "Solitary Coral, A Reply," was published in *A Visitor at the Gate*, chapbook, Shinola Press, 1996.

My deep gratitude to the Corporation of Yaddo for two residencies, in 2004 and 2008, which enabled this book. And thanks to The Virginia Center for the Creative Arts for the weeks in which "Unbinding" found its form.

PHOTO BY ROBERT DIAMANTE

ABOUT THE AUTHOR

My grandfather, Nicola Maria Silvestri, emigrated from Vico del Gargano ("The Village of Love,") Italy, in 1911. He moved with his two brothers, all of them illiterate, to the Norristown, PA area. My father, John J. Sylvester, was born there in 1922, the oldest of three siblings. (Their mother, Maggie, also Italian, would Anglicize the last name and then move the family across Main Street into a red brick house.) My father was their first college graduate, starting as "Swivel Hips" at Norristown High, then quarterback at Temple University, before serving on the Army Football Team, on Guam. After the war, he continued playing football as a running back, first for the New York Yankees (then a football team), and then the Baltimore Colts.

My parents met in NYC in 1946. They were both living the post WW II dream of blue-collar families making it bigger. When I was born, though, my father was a steel worker in Youngstown, Ohio, my mother's hometown, where he'd moved to please my mother, Joan, a former Conover model, Anglo-Saxon, and a sufferer from depression, anxiety and, eventually, alcoholism. Like many families in the '50s and '60s, a neat yard, new house and, eventually, company car, could only partly disguise what was going on inside.

Only witness to the family drama, I left home after less than two years of college and moved to NYC with my boyfriend, thereafter

working through 1.5 marriages, the BA program in poetry at Goddard College, and then its MFA Program. A stint in the PhD Program in Creative Writing and Literature at the University of Utah from 1979-80, sent me on a pilgrimage that culminated with the eventual completion of my PhD at Utah in 1991. In the interim years, I lived in New York, Florida, Massachusetts, and Virginia—a peripatetic work pattern that would continue until 2012, when, having also sampled the academic delights of Kansas, Ohio, South Carolina, I chose to return to New England, a place that, like poetry, made sense to me.

As with many immigrant families, my Italian relatives weren't very interested in where they came from. With the help of the Ellis Island Foundation, though, I found the ship's manifest that Nick signed with a big X, and bought a photo of the Calabria, the ship—with three staterooms, the rest steerage—that carried him from Genoa to NYC. Nick's X: the mark of a man who never learned English; whose wife chased him around a spotless kitchen with her heaviest frying pan; who liked to make his little granddaughter laugh by displaying his one tooth; who drank and yelled; who grew tomatoes and basil; who kept chickens; who dug ditches; who bequeathed his sexism and temper to his son; who died at home, in bed, when I was ten, the ever-exasperated, indomitable Maggie at his side. Grazie mille.

LAURIA/FRASCA POETRY PRIZE

The prize was conceived to promote the poetry of the Italian diaspora in English. Quality poetry in any style and on any theme is sought.

JANET SYLVESTER. *And Not to Break.* Vol. 2. 2019
MATTHEW CARIELLO. *Talk.* Vol. 1. 2018

www.ingramcontent.com/pod-product-compliance
Lightning Source LLC
Chambersburg PA
CBHW022120090426
42743CB00008B/934